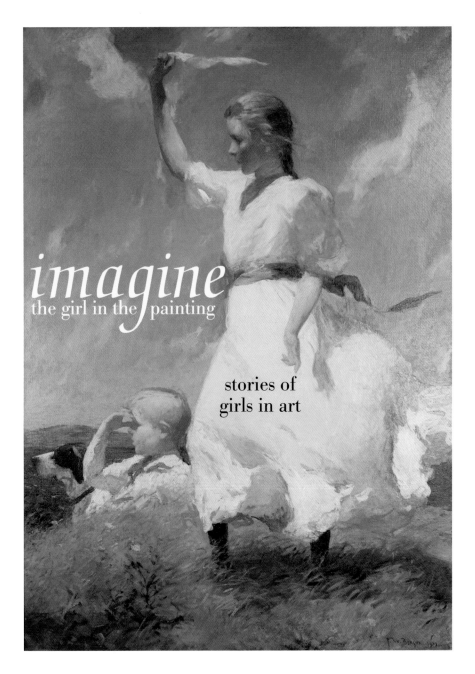

imagine

the girl in the painting

stories of
girls in art

Published by Pleasant Company Publications

Visit our Web site at americangirl.com

Printed in Hong Kong.

02 03 04 05 06 07 C&C 10 9 8 7 6 5 4 3 2

Editorial Development: Nancy Holyoke, Harriet Brown, Judy Woodburn, Elizabeth Chobanian

Design: Camela Decaire, Chris Lorette David

Production: Kendra Pulvermacher, Mindy Rappe

Credits

Mary and Elizabeth Royall, Courtesy, Museum of Fine Arts, Boston. Reproduced with permission. © 2000 Museum of Fine Arts, Boston. All Rights Reserved. *Mary and Elizabeth Royall*, about 1758, John Singleton Copley, American (1738–1815), Oil on canvas, 57 3/8 x 48 1/8 in. (145.7 x 122.2 cm), Julia Knight Fox Fund, 25.49; **The Hatch Family,** The Metropolitan Museum of Art, Gift of Frederic H. Hatch, 1926 (26.97). Photograph © 1999 The Metropolitan Museum of Art; **Sunlight and Shadow,** Winslow Homer (American, 1836–1910), United States, *Sunlight and Shadow*, 1872, oil on canvas, 15 13/16 x 22 5/8 in., Cooper-Hewitt, National Design Museum, Smithsonian Institution/Art Resource, NY, Gift of Charles Savage Homer, Jr., 1917-14-7, Photo, Michael Fischer; **The New Scholar,** Jennie Brownscomb, *The New Scholar* (0126.1213), From the Collection of Gilcrease Museum, Tulsa; **Two Girls Looking at a Book,** Courtesy, Museum of Fine Arts, Boston. Reproduced with Permission. © 2000 Museum of Fine Arts, Boston. All Rights Reserved. *Two Girls Looking at a Book*, about 1877, Winslow Homer, American (1836–1910), Watercolor over charcoal on paper, sheet 5 3/8 x 8 5/8 in. (13.6 x 22 cm), Bequest of the estate of Katherine Dexter McCormick, 68.572; **On the Beach,** Winslow Homer, *On the Beach*, Courtesy of the Canajoharie (NY) Library and Art Gallery; **New Year's Day in San Francisco Chinatown,** Dr. A. Jess Shenson; **The Daughters of Edward D. Boit,** Courtesy, Museum of Fine Arts, Boston. Reproduced with Permission. © 2000 Museum of Fine Arts, Boston. All Rights Reserved. *The Daughters of Edward Darley Boit*, 1882, John Singer Sargent, American (1856–1925), Oil on canvas, 87 3/8 x 87 5/8 in. (221.9 x 222.6 cm), Gift of Mary Louisa Boit, Julia Overing Boit, Jane Hubbard Boit, and Florence D. Boit in memory of their father, Edward Darley Boit, 19.124; **Kept In,** Fenimore Art Museum, Cooperstown, New York. Photo, Richard Walker; **Jungle Tales,** The Metropolitan Museum of Art, Arthur Hoppock Hearn Fund, 1913 (13.143.1). Photograph © 1988 The Metropolitan Museum of Art; **Japanese Lanterns,** Collection of the Tweed Museum of Art, University of Minnesota, Duluth, gift of Howard W. Lyon; **May Day,** Maurice Prendergast, American, 1858–1924, *May Day, Central Park.* Watercolor, 1901, 35.4 x 50.6 cm, © The Cleveland Museum of Art, Gift from J.H. Wade, 1926.17; **The Hilltop,** Frank Benson, *The Hilltop*, Courtesy of the Malden (MA) Public Library; **Children Roller Skating,** William Glackens, American, 1870–1938, *Children Roller Skating*, ca. 1918–1921, oil on canvas, 61.0 x 45.7 cm. (24 x 18 in.), Brooklyn Museum of Art, Bequest of Laura L. Barnes 67.24.1; **Backyards, Greenwich Village,** Photograph Copyright © 2000, Whitney Museum of American Art; **The Prairie is My Garden,** *The Prairie is My Garden* (1950) by Harvey Dunn, South Dakota Art Museum Collection; **Mother Goose Tales,** from a private collection; **Thanksgiving,** Doris Lee, American, 1905–1983, *Thanksgiving*, c.1935, oil on canvas, 71.3 x 101.8 cm, Mr. and Mrs. Frank G. Logan Prize Fund, 1935.313, © The Art Institute of Chicago. All Rights Reserved; **Li'l Sis,** Copyright Smithsonian American Art Museum, Washington, DC/Art Resource, NY; **Girl at Mirror,** *Girl at Mirror*, Printed by permission of the Norman Rockwell Family Trust, © 1954 the Norman Rockwell Family Trust.

Library of Congress Cataloging-in-Publication Data
Imagine the girl in the painting : stories of girls in art
p. cm.
"American girl library."
ISBN 1-58485-578-9
1. Girls in art—Juvenile literature. 2. Painting—Appreciation—Juvenile literature. 3. Painting, American—Juvenile literature. I. Pleasant Company Publications. II. American girl (Middleton, Wis.)
ND1460.G57 I46 2002
757'.5–dc21 2001058758

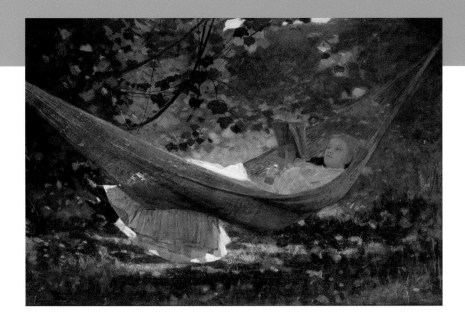

imagine you're alone in a leafy green paradise.

Peek into the paintings inside and experience art in a whole new way. Read the stories and let your imagination create each girl's life. From 1758 to 1954, winter to summer, San Francisco to France, you'll discover colors, feel the sun and wind, hear laughter.

In the back of this book you'll also find your own mini art collection to display. Slip an art card into the front cover, and look closely. What do you see in each painting? What do you smell? Can you make each girl come to life?

It's an adventure. What do you imagine?

Your friends at American Girl

imagine you and your dog are having your portrait painted.

Except you don't have a dog. The year is 1758. You are 11-year-old Elizabeth Royall, and you live near Boston. One day you put on a green dress and sit quietly beside your older sister, Mary, while Mr. John Singleton Copley paints your portrait. Your hands are empty, but the finished painting shows a dog on your lap and a hummingbird perched on Mary's finger.

The animals are *attributes*, or clues, that the artist put in the picture to tell something special about the people in the painting. The dog might mean that you are a lively young girl who would rather be playing with a puppy than sitting in a parlor. And the hummingbird? Maybe it suggests that Mary's childhood is flying away. Now think about yourself, as you really are, today. If you were having your portrait painted, what might you be holding?

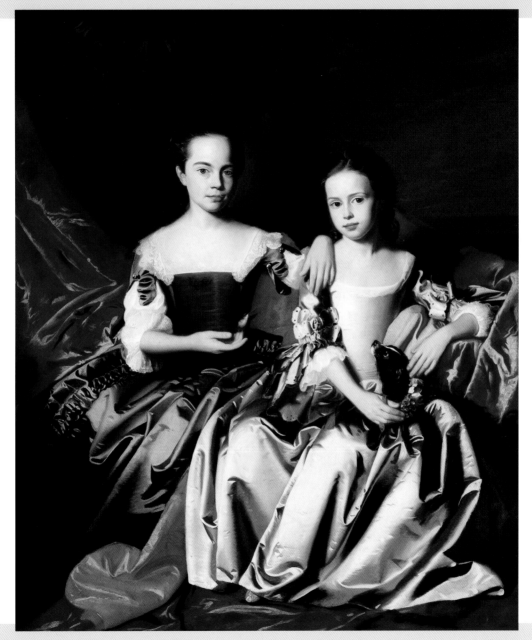

Mary and Elizabeth Royall,
by John Singleton Copley, 1758

imagine you have nine brothers and sisters. Make that ten!

It's 1871, and you live in New York City. For more than a year, a painter named Eastman Johnson has been painting a portrait of your family—including your grandparents and all the kids.

Mr. Johnson decided early on to make Jessamine, your baby sister, the center of attention. He asked you to hold her, and he positioned the rest of the family looking at the two of you. Since then, he's been working on each person's likeness one at a time, doing studies, or sketches, and then combining them on the larger canvas of the painting.

You've got a big family, and the process has taken months. In the meantime Jessamine began to crawl, then walk. Not only that: your mother has had another baby—a little girl named Emily Nichols. Nobody had counted on her!

Your father wants the portrait to include everybody, so at the last minute Mr. Johnson makes a clever switch. In the finished painting, Jessamine appears as a toddler, in a white dress with a blue sash. She is clutching your mother's skirt and looking jealously at Emily, who has replaced her in your lap. Poor Jessamine! Emily looks as if she's been the star of the painting all along.

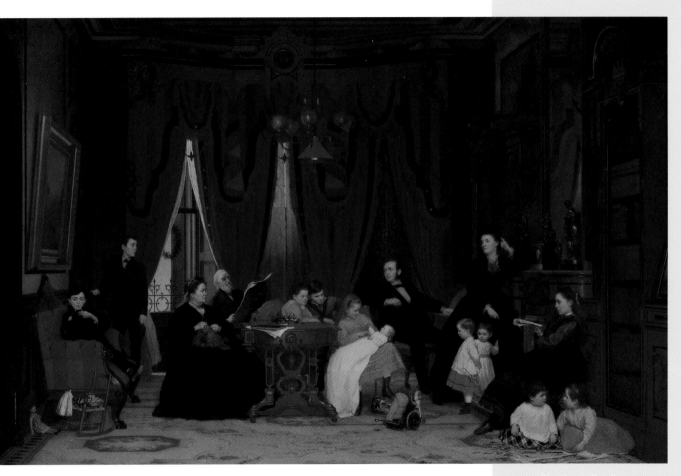

The Hatch Family,
by Eastman Johnson, 1871

imagine you're alone in a leafy green paradise.

It's 1872. You and your cousins have been waiting all year for summer, and now it's finally here. What a splendid time you're having! You've spent hours here at your cottage in Massachusetts, rolling hoops, jumping rope, and playing with your dolls. You've even learned to climb a tree—which isn't easy when you're wearing a long skirt!

Today your cousins are going berry picking, and they begged you to come, too. But just for today, you feel like staying right where you are.

"You'll be all by yourself," your cousins warn as they scamper off through the woods, berry baskets swinging in their hands. You barely hear them go. Lying in your hammock, you're already deep in the world of *Little Women*.

You read, spellbound, about Jo, Beth, Meg, and Amy. When the handsome young Laurence boy moves in next door, you're as curious as the March sisters. And when tragedy strikes, you cry right along with them. Your cousins may be long gone, but you're not lonely. You've got all the company you need right here in your hands.

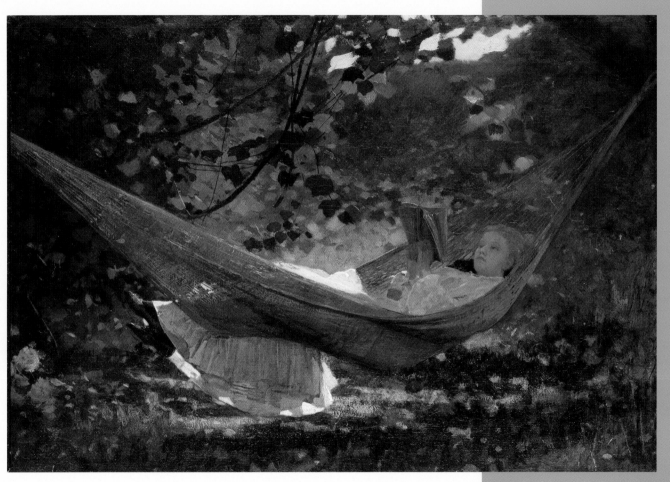

Sunlight and Shadow,
by Winslow Homer, 1872

imagine the schoolyard is full of strange faces.

It's a quarter to eight on a September morning in 1878. The first day of school is about to start any minute, and your heart is pounding so loudly, you're sure everyone can hear it. It's terrible being the new girl in town!

Back home, you'd be talking and laughing with your friends, full of excitement about the new year. Here, you're full of dread. What if you have to share a bench with the little children? What if no one will eat lunch with you? Worse yet, you've heard this school has a new blackboard as big as one wall. You've never seen a blackboard before. What if you're asked to write on it—in front of everyone? You can't imagine anything worse!

Clutching your hand-me-down reader and spelling book, you wonder how you'll survive until spring. But just then, a girl in a pretty straw hat catches your eye. "Hello!" she says. "My name is Emily. Would you like to share my bench?" Before you answer, you breathe a huge sigh of relief. No matter what happens, it won't seem so awful with a new friend by your side.

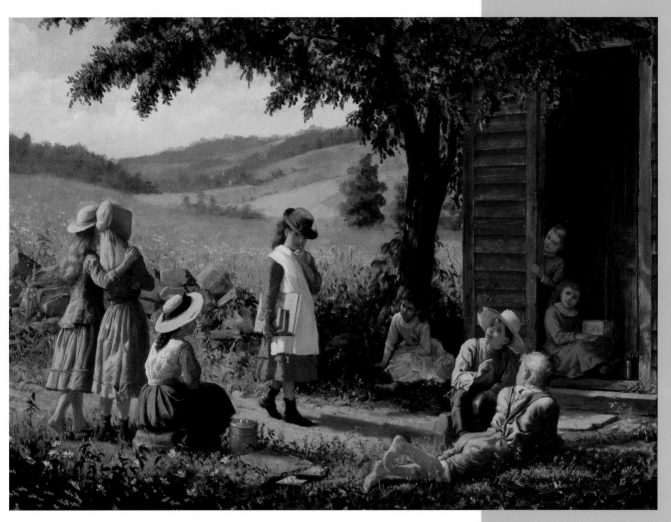

The New Scholar,
by Jennie Brownscomb, 1878

imagine you're lost in an adventure.

It's 1880. You and your friend Fanny are huddled over a book called *Alice's Adventures in Wonderland*. You started reading it together two days ago, and now you can't put it down.

You've never seen a book with such unusual drawings. And you've never read about a girl with such an interesting story. Lucky Alice! One dreary afternoon, a white rabbit rushes past her in an enormous hurry. Then all kinds of amazing things happen. Alice grows big as a house, shrinks small as a mouse, and even plays croquet with a queen!

When you read the end of the chapter, you gaze out the window and try to imagine what it would be like to have an adventure as marvelous as Alice's. But, Fanny says with a sigh, this isn't Wonderland. Nothing like that could happen here.

Just then, a tiny animal skitters across the yard and disappears under a hedge. You and Fanny stare at each other in surprise. Wasn't that a rabbit? And didn't he seem to be in a *terrible* rush?

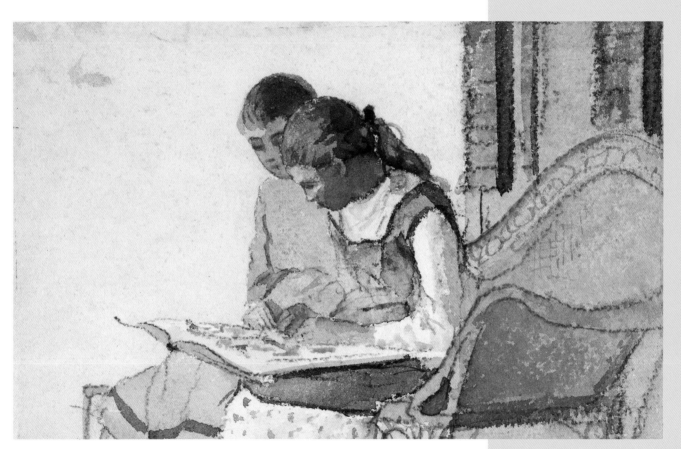

Two Girls Looking at a Book,
by Winslow Homer, about 1877

imagine you are standing with your toes in the surf.

It's 1880, and your parents have sent you away from the soot and dirt of the city to spend the summer in a fishing village on the coast of Maine. It's too cool to swim, so you take off your stockings and hike up your skirt and go wading instead. Your hat stays on, because you don't want to get any unladylike freckles!

Behind you, near the beach, a painter is working. This is Winslow Homer, who thinks this is the most wonderful place in the world. Some of Mr. Homer's paintings might scare you if you saw them—paintings of sharks and shipwrecks and sailors lost on terrible, stormy seas. But the ocean he is painting today is a calm one, where children play along the shore.

As Mr. Homer works, you and your friends are looking for shells, with your heads bent down and the waves washing over your feet. You don't see what he sees: ships, their sails tiny specks of white on the wide horizon.

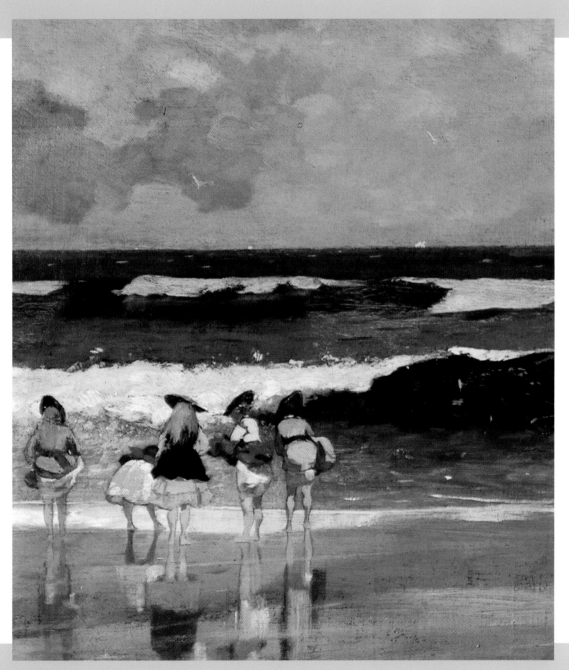

Detail from *On the Beach*, by Winslow Homer, about 1880

imagine it's the first day of the Chinese New Year.

For the next week, everyone in your neighborhood, San Francisco's Chinatown, will be celebrating. This morning your grandmother gave you and your sister coins wrapped in red paper. They're called *li shee*, or good-luck money, because red is supposed to be a lucky color. Your grandmother told you about another symbol of good luck: finding a flower that blooms on New Year's Day.

Now you and your sister and mother are at the flower stand. The Chinese flower farmers here in California save their nicest flowers for New Year's. Your mother takes her time, looking for the best flowers. You look, too, your eyes scanning the potted bulbs arranged in neat rows.

Finally you see it: a pot of bright red tulips, just beginning to bloom. Your mother pays the flower seller and hands the pot to you. The pot of tulips is heavy, but your heart is full of happiness as you head home, because you know that this new year will bring plenty of good luck.

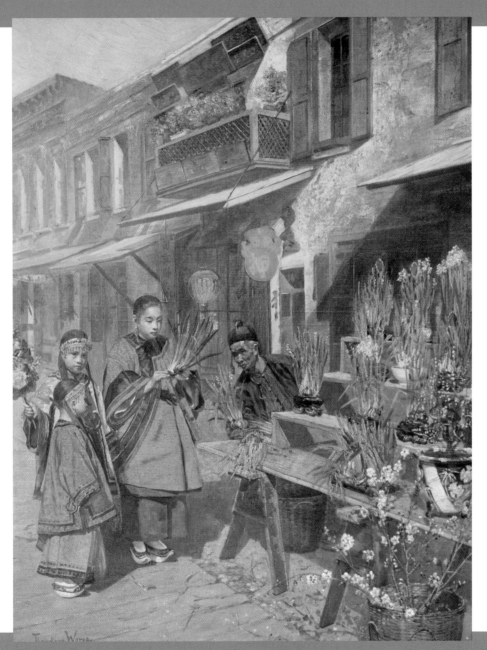

New Year's Day in San Francisco Chinatown, by Theodore Wores, 1881

imagine you're a girl living in an apartment in France.

Home is really Massachusetts, but for now you're living here, with your father, Edward Boit, a rich painter. One day a friend of your father's comes to paint a portrait of you and your sisters. His name is John Singer Sargent.

People are usually the most important part of a portrait. But in his portrait of you, Mr. Sargent paints the room as well, with its high ceilings, dark corners, and huge Oriental vases. He even paints your oldest sister, Florence, with her face hidden in the shadows. Many parents would have refused to pay for this painting for just that reason. Yet *The Daughters of Edward D. Boit* became famous because Mr. Sargent broke the portrait painter's rules.

What was Florence feeling, standing in the dark in her white pinafore? Was she shy about having her picture painted? Maybe she was annoyed at having to stand still for so long!

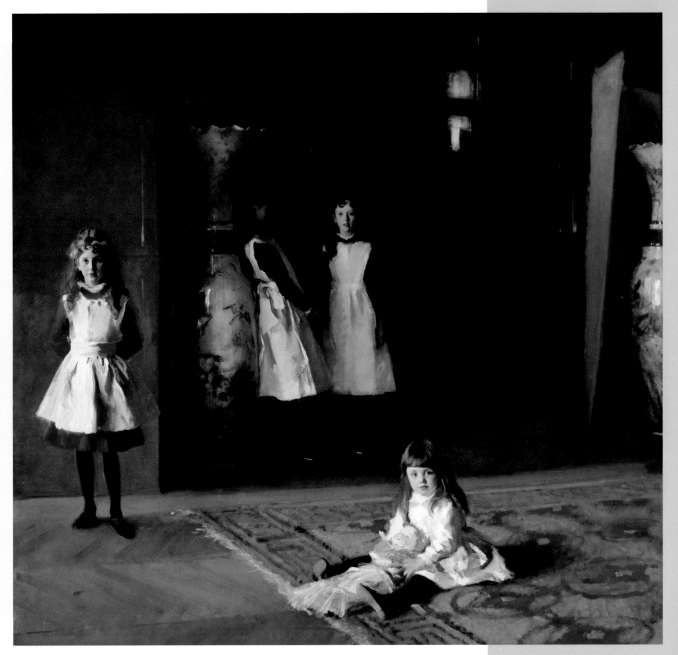

The Daughters of Edward D. Boit,
by John Singer Sargent, 1882

imagine your new teacher is terribly unfair.

It's September 1889, your first day in a new school. At your old school, everyone was black. But not long ago the state of New York, where you live, passed a law saying that black children and white children must go to school together.

Mama says you'll get a better education at the new school. She says it has more books and teachers than your old school. In fact, that's why the new law was passed, so children like you could get a better education. But this morning, as she braided your hair, she warned you that some of the white children might be mean at first.

So far, your classmates have been friendly. One red-haired girl slipped you a peppermint and a smile. The teacher saw her do it—and said that only *you* had to stay in at lunchtime.

Sitting in the stuffy classroom now, you feel like crying. Then the red-haired girl peeks in the window and winks, and suddenly you feel better. So what if the teacher keeps you inside? She can't keep you from making friends, or from learning all you can. That, you realize, is up to you.

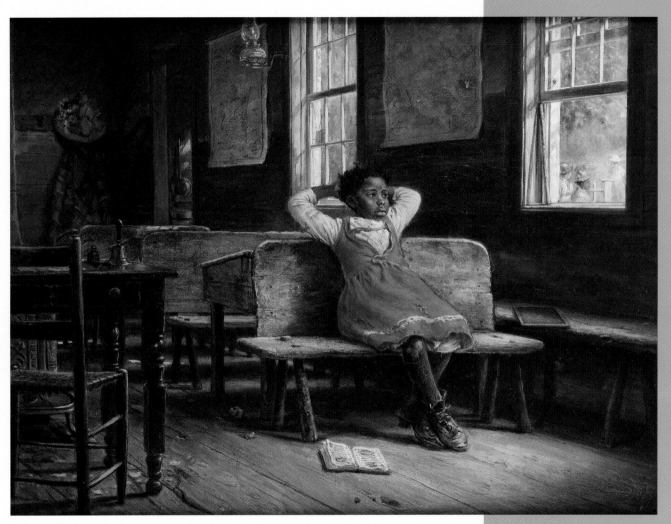

Kept In,
by Edward Lamson Henry, 1889

imagine your mother's voice takes you away to India.

You're a proper young lady in a dress of ruffles and flounces. How wonderful and strange this tale of adventure is to a girl like you. India! It glows in your mind as your mother reads.

When your mother was young, only rich people owned books. But now it's 1895. People have more money than they did when she was a girl. You can buy books for ten cents, and magazines and newspapers are everywhere. Reading is a national craze.

Best of all, there are lots of wonderful new books for girls like you: *Heidi*, *The Five Little Peppers*, and a horse book called *Black Beauty*—oh, how you cried over that one! There's even a new book by Rudyard Kipling, the young Englishman famous for his stories about India. It's *The Jungle Book*, the story you're listening to tonight.

The lamplight flickers across your mother's cheek. The tiger has come for baby Mowgli. Mother Wolf springs up with a cry: *"The man cub is mine!"* Hush! Listen.

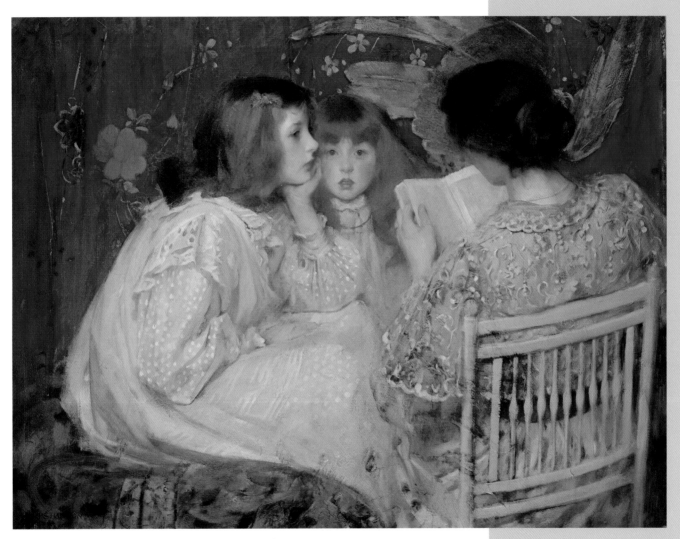

imagine you hold a glowing lantern in your hands.

It's 1895, and you and your sister are lighting Japanese lanterns for your parents' garden party. Japan is all the rage these days. Americans are buying Japanese furniture, Japanese wallpaper, Japanese fans and vases—they're even having parties like this one, where they hang Japanese lanterns on their American trees.

Lights made of paper! You've never seen anything like them. They come from Japan's *Obon* festival, when the spirits of the dead are said to return to visit the living. During *Obon*, families put lanterns by their houses and in graveyards to light the way home for their loved ones. For three days people feast and dance, celebrating their love for their ancestors, and all Japan is lit with thousands and thousands of paper lamps.

As the lanterns glow among your mother's roses, your heart stirs and you think: *There's more to the world than what I see with my eyes.*

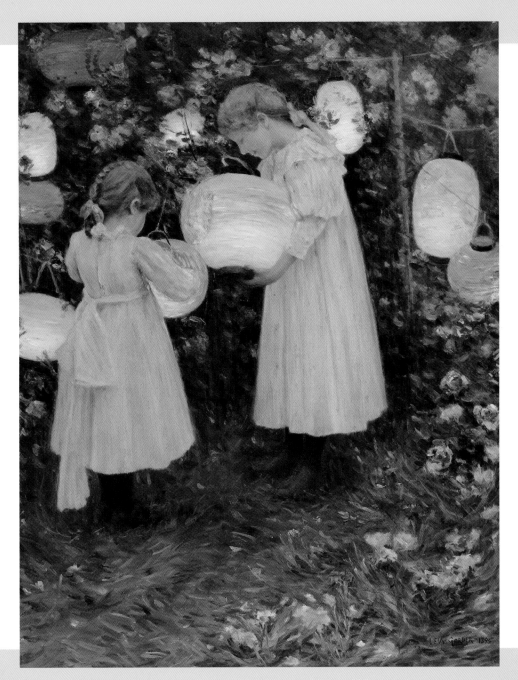

Japanese Lanterns, by Luther Van Gorder, 1895

imagine you have a circle of flowers in your hair.

It's May 1, 1901. You're in Central Park, the big green park in the heart of New York City. Here thousands of girls have gathered for May Day parties, held to celebrate the coming of spring.

Your own party begins with a parade of girls holding baskets of flowers, colorful hoops, banners, flags, and maypoles. Then a call goes out: "Silence! Make way for the Queen of the May!" One lucky girl steps forward to be wreathed with flowers by her friends. How you wish it were you!

But there's no time to think about that. You and the other girls must entertain the queen by dancing the maypole. The dancers catch hold of streamers—and the fun begins. You face to the right, skip to the left, skip to the right. As you dance, you sing, and the ribbons wind around the pole. Your throat fills with laughter. Your feet skim the grass. The lawn becomes a jumble of hats and dresses, and the queen disappears in the crowd. Poor queen! She can only watch!

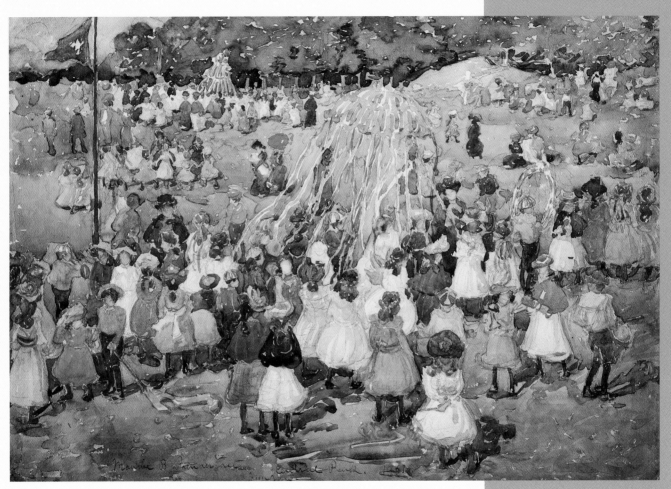

May Day, Central Park,
by Maurice Prendergast, 1901

imagine you hear a ferryboat's deep whistle.

It's a sunny summer morning in 1905. You're at the top of a hill on a little island in Maine, gazing out over the cool waters of the Atlantic Ocean. You live in Boston, but each summer your family rides a ferryboat here to North Haven Island so you can run and play at your summer home, Wooster Farm.

Today, the ferry is bringing your Aunt Katie to visit. As you and your brother wait with your dog, Togo, you talk about your last ferry ride. How elegant it was! You even got to eat in a real dining room, where the tables gleamed with white cloths and the funny round portholes were curtained in silk. Still, the best part of the ferry ride was seeing who could spot Wooster Farm first.

As you watch the horizon, you hear the ferry's low "tooot-toot." Soon you see the boat's big paddle wheel throwing sparkling water high in the air. You wave your handkerchief gaily. Someone in a red hat waves back. Is it Aunt Katie? Did she see you? You can hardly wait till the carriage arrives from the village to see if she did!

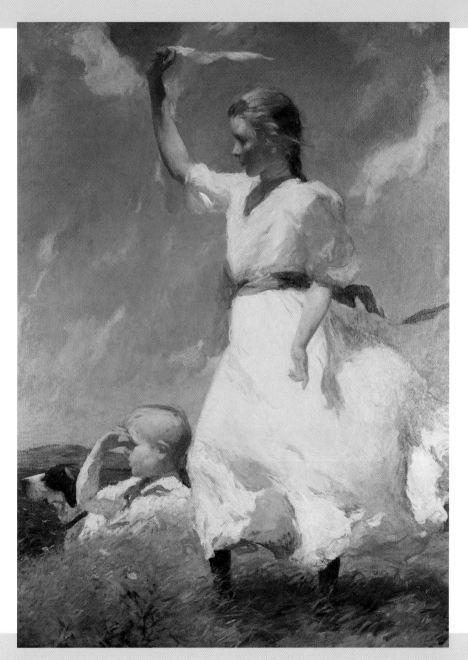

The Hilltop, by Frank W. Benson, 1905

imagine you are on roller skates for the first time.

It's a chilly Saturday afternoon in 1918. You're wearing your usual Saturday outfit: wide-brimmed hat, proper blouse and skirt, stockings—and your brand-new roller skates!

Skating has been very popular ever since your grandma was a girl in the 1860s. Her roller skates were heavy and hard to use, but yours have metal wheels and ball bearings, so you can skate like the wind—once you get good enough!

As you wobble around the park near your house in New York City, trying not to fall and rip your stockings, you don't notice the man sketching. His name is William Glackens. Most artists show people in stiff, formal poses. But Mr. Glackens likes to paint people doing everyday things. Maybe that's why he's drawn you and your friend on roller skates—you with your arms out for balance and your friend holding on to her hat!

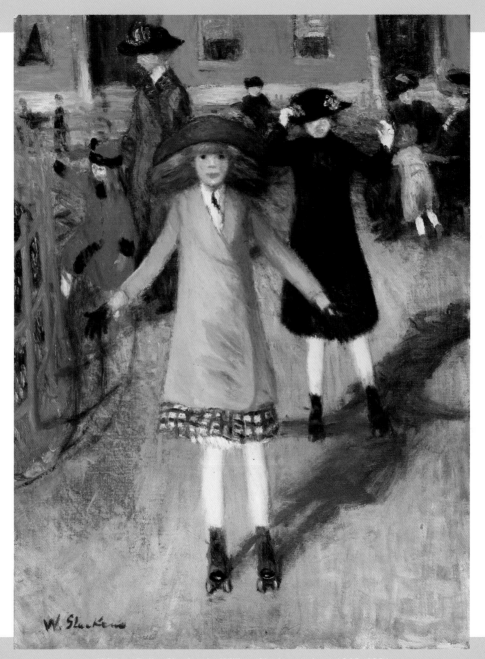

Children Roller Skating, by William Glackens, about 1918–1921

imagine your tiny backyard is frosted with snow.

You live in Greenwich Village, a lively neighborhood in New York City where apartment buildings like yours line almost every crooked street. On a wintry morning in 1914, you peer out your window. The children who live upstairs from you are building a snowman. You would join them in a flash—if only you could find your mittens!

Your neighbor, Mr. John Sloan, is peering out his window, too. Like many people who live in Greenwich Village, he is an artist. Later, in his studio, he will paint a picture of your yard from memory. He won't forget a thing—not even your frozen laundry flapping on the clothesline overhead!

People wonder why your neighbor loves to paint backyards, alleys, and ordinary kids. They say a common neighborhood like yours can't possibly be beautiful. He should paint skylines, or sunsets!

But as you gaze out on your tiny backyard, you begin to notice things. See how the sun glows on the fence boards? See the pale purple shadows on the snow? This morning, you know your neighbor is right: you can find beauty everywhere, if you look with loving eyes!

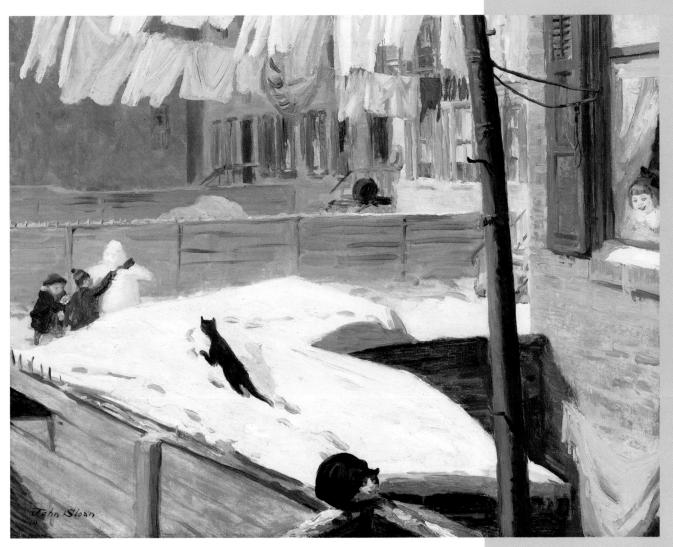

Backyards, Greenwich Village,
by John Sloan, 1914

imagine you have your very own secret garden.

It's early July, and the Kansas prairie is hot enough to pop corn. At least that's what your mother said this morning. You know she was joking, but you can't help wondering if the corn in the field really will start popping off its stalks!

Today is also your birthday, and to celebrate, your mother gave you and your sister a holiday from chores. Most summer days you're out in the fields, weeding your family's crop of wheat and corn. The work makes your back ache and your fingers numb. Still, it has to be done.

But today you and your sister and mother walk out onto the prairie together. Your mother knows a special spot where wildflowers bloom this time of year—your family's own secret garden.

You gather armfuls of flowers, as many as you can carry. When you get home, you'll arrange them in buckets of water all through the house—bright bouquets of blooms. And tomorrow afternoon, when you come in from the fields all sweaty and exhausted, you'll breathe in their sweet prairie smells, and you'll smile.

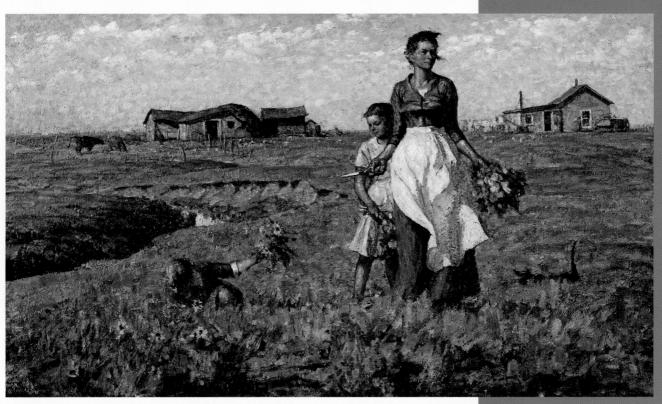

The Prairie is My Garden,
by Harvey Dunn, 1950

imagine your world is alive with rhymes and stories.

It's 1935. You live in Harlem, in New York City—the most exciting black neighborhood there is. You're home from school, reading *Mother Goose:*

"If all the world was apple pie

And all the sea was ink . . ."

You know every page of this book. Jack and Jill, pigs and kings, blackbird pies . . . These rhymes have existed for hundreds of years, recited by people in lands far away—recited over and over till one day someone wrote them down.

You hear rhymes and songs and stories all the time in Harlem, too. Outside your window, the streets are alive with men singing, grandmothers telling tales, peddlers calling:

"I got vegetables today, so don't go away.

Stick around, and you'll hear me say:

Buy 'em by the pound, put 'em in a sack.

Hurry up and get 'em, cause I'm not coming back."

You stop reading and listen to the song. What a book it would make if someone wrote these street rhymes down, too. Listen well, remember all you hear, and maybe it will be you.

Mother Goose Tales,
by Palmer Hayden, about 1935

imagine for once, you're glad to be hard at work.

It's Thanksgiving 1935, in the small town of Aledo, Illinois. You and your mother and your aunts have been awake since dawn, cooking and baking, preparing the Thanksgiving meal. Your father and brother *never* help! Your brother thinks he's lucky to get out of doing all the work, but you know he's wrong.

You *love* these hectic hours in the kitchen. The women crisscross the room, joking and talking and working. You stand on a stool, dangling a cranberry for the cat, inhaling the heavenly aromas of turkey and pumpkin pie. Being in this warm, busy kitchen is like being wrapped in a great big hug.

When you set the table for dinner, you turn each plate upside down and put three corn kernels underneath. That's all the food the Pilgrims had their first winter, before the supply ships came. The corn reminds you to be thankful for the meal, and you are. But you're even more thankful for something you can't eat: this long morning of love and friendship and family.

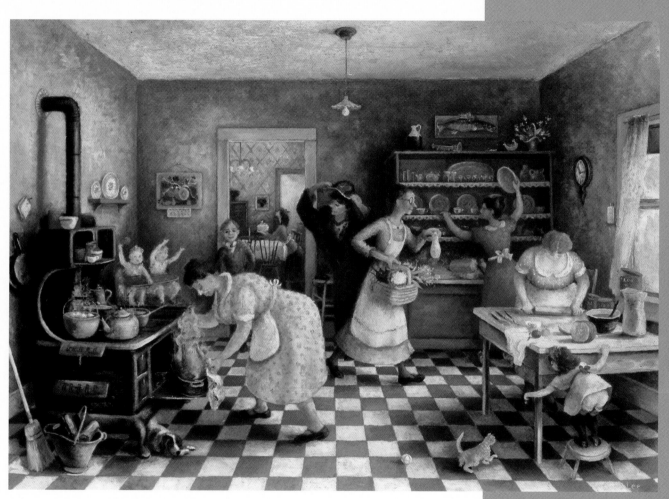

Thanksgiving,
by Doris Lee, about 1935

imagine it's a steaming hot summer afternoon.

On any other summer's day you'd be swimming with your friends in the creek. But today is special. Today your Uncle Willie is finally going to paint your picture!

Your uncle, William Johnson, is a famous painter, and he's come home to Florence, South Carolina, for a visit. For weeks he's been painting pictures of everybody in town, and now it's your turn. As you pose with your doll, you swat away the flies that are pestering you. And as Uncle Willie paints, he tells you about life in New York City, where the buildings are as tall as the sky.

When he's done, Uncle Willie lets you take a peek. It certainly doesn't look like you! But somehow this picture *feels* like it's really you, with your doll by your side and a bow in your hair, standing with your bare feet in the hot dirt. Uncle Willie even shows you clutching the flyswatter. It feels like you and it feels like summer—just as Uncle Willie wanted it to.

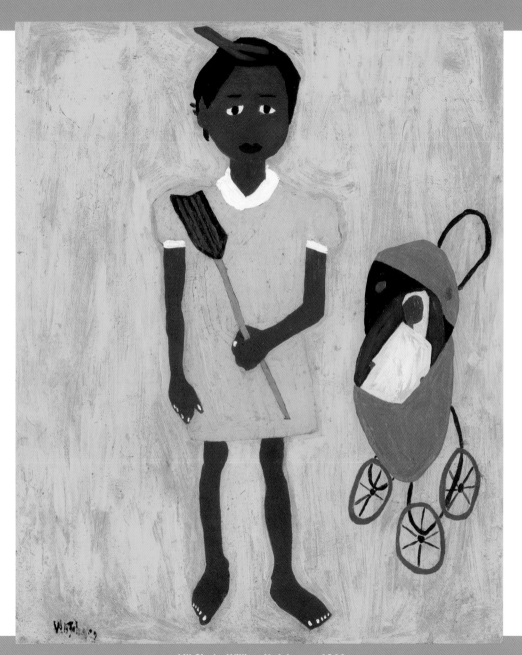

Li'l Sis, by William H. Johnson, 1944

imagine it's Saturday night in 1954.

Your older sister has gone to a basketball game at the high school. Finally, you have a chance to peek at her movie magazine. You've taken great care not to crinkle the pages, especially the one you're open to now—a picture of actress Jane Russell. She's so beautiful!

Will you look like her someday? Do you look like her now—even just a little? You've parted your hair down the middle, pulled it up and dabbed your lips with your mother's lipstick. Still, something's missing.

Last year Jane Russell was in a movie with Marilyn Monroe called *Gentlemen Prefer Blondes*. Even though you love musicals, you weren't allowed to go. But your sister could! Afterward, she and her friends practiced their impressions of Marilyn, singing "Diamonds Are a Girl's Best Friend," a famous song from the movie.

Someday you'll be able to go to any movie you want, and you'll look just like Jane Russell. But for now, you'll spend your Saturday nights at home. You'll wipe off your mother's lipstick, undo your hair, and go back to playing with your favorite doll. Someday you'll be grown-up. Just not today.

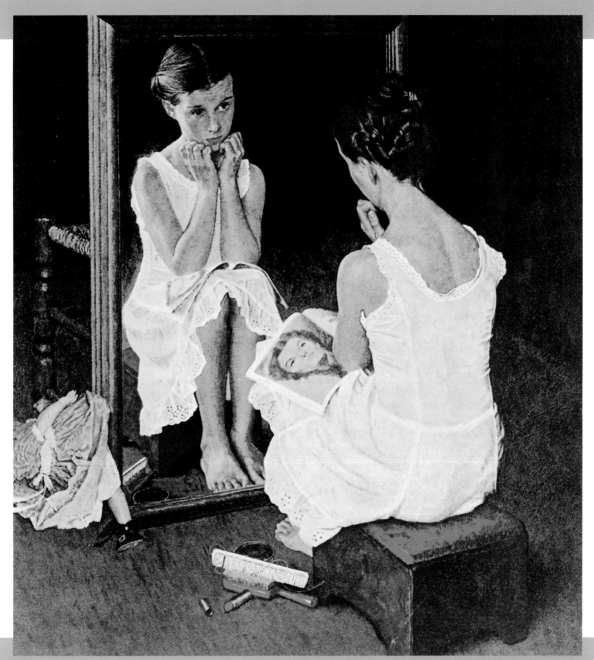

Girl at Mirror, by Norman Rockwell, 1954

the lives of the artists

Here's a glimpse at the lives of the artists who created these paintings. Though they lived in different times and places, these people shared a common goal: to capture a moment in a girl's life. For more information on each artist or painting, visit your local library.

John Singleton Copley
1738–1815

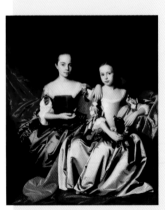

Mary and Elizabeth Royall, from the Museum of Fine Arts, Boston, Mass.

Copley was born and raised in Boston. He was good at capturing details and textures, and he liked to use bold colors. He worked very slowly, often trying the patience of his subjects. He was a friend to John Hancock and Paul Revere, but when tensions grew after the Boston Tea Party in 1773, Copley moved to London.

Eastman Johnson
1824–1906

Johnson grew up in Maine. His favorite subjects included African Americans, scenes of the Civil War, and country life in Maine and Nantucket. But it was his portraits that were in greatest demand. Wealthy people hired Johnson to paint them in their elegant homes. The Hatch family was painted in the library of their New York mansion.

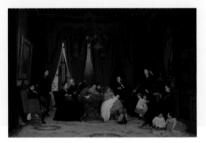

The Hatch Family, from The Metropolitan Museum of Art, New York, N.Y.

Winslow Homer
1836–1910

Homer was born in Boston. After a trip to Paris in 1867, he focused on painting country life, children playing, and women working and relaxing. In 1881–82, Homer lived in a fishing village in England, where he painted fishermen, divers, sailors, and the sea. He returned to Maine in 1883, and continued to paint the sea until his death.

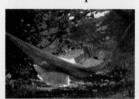

Sunlight and Shadow, from the Cooper-Hewitt, National Design Museum, Smithsonian Institution, New York, N.Y.

On the Beach, from Canojoharie Library & Art Gallery, Canajoharie, N.Y.

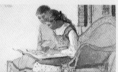

Two Girls Looking at a Book, from the Museum of Fine Arts, Boston, Mass.

Jennie Brownscomb
1850–1936

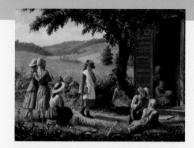

The New Scholar, from the Gilcrease Museum, Tulsa, Okla.

Brownscomb was born in a log cabin in Pennsylvania. As a child, she loved to draw, and she won ribbons at county fairs for her drawings. She studied painting in America and Europe and became known for her scenes of early American history. Brownscomb's work also appeared in magazines, on cards, and on calendars.

Theodore Wores
1859–1939

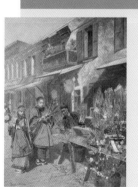

New Year's Day in San Francisco Chinatown, from a private collection

Wores was born in San Francisco. Throughout his life, he loved to travel and paint the people he met along the way. His travels took him to Japan, Hawaii, Samoa, and Canada. Wores looked for exotic subjects, and he was especially interested in Asian art. One of his favorite subjects was the people of San Francisco's Chinatown.

John Singer Sargent
1856–1925

Sargent's parents were American, but he was born in Florence, Italy. His family traveled throughout Europe, and he learned to speak French, Italian, German, and English. In 1876, he went to America and became a citizen. But he continued his travels and work in Europe. His specialty was portraits of wealthy people.

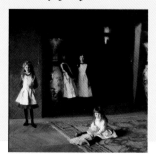

The Daughters of Edward D. Boit, from the Museum of Fine Arts, Boston, Mass.

Edward Lamson Henry
1841–1919

Henry was born in Charleston, South Carolina. After studying in Paris for two years, Henry returned to New York City in 1862, where he eventually settled. In 1864, he became a captain's clerk on a boat in Virginia, where he drew soldiers and scenes of the Civil War period. Henry's work was very detailed, and he often chose sentimental scenes from the early 1800s.

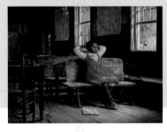

Kept In,
from the Fenimore
Art Museum,
Cooperstown, N.Y.

James J. Shannon
1862–1923

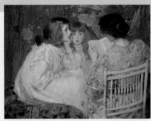

Jungle Tales,
from The Metropolitan
Museum of Art,
New York, N.Y.

Shannon was born in Auburn, New York. When he was 16, he went to England. He was going to stay there for only a few years, but he ended up living in London for the rest of his life. He was a leading portrait artist in Europe. Even Queen Victoria hired him to paint a portrait of her lady-in-waiting. This created a great demand for his portraits. In 1922, just one year before his death, he was awarded a knighthood for his art.

Luther Van Gorder
1861–1931

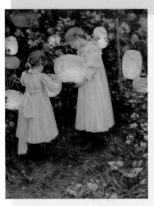

Japanese Lanterns,
from the Tweed Museum
of Art, University of
Minnesota, Duluth

Van Gorder was born in Ohio. In 1894, he went to Paris to study art. He is best known for his paintings of Parisian flower markets and French landscapes. Van Gorder lived in Europe until his return to Toledo in 1901. There, he continued to paint street scenes and landscapes until his death.

Maurice Prendergast
1858–1924

Prendergast was born in Canada. When he was ten years old, his family moved to Boston. His favorite subjects were the parks and beaches of New England and Italy, and his paintings show people enjoying themselves. Prendergast was a leader in what was considered modern art at the time. He traveled and worked throughout Europe, eventually settling in New York City in 1914.

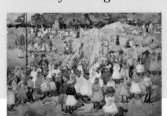

May Day, Central Park,
from The Cleveland Museum
of Art, Cleveland, Ohio

Frank Benson
1862–1951

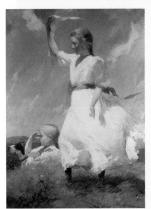

The Hilltop,
from the Malden Public
Library, Malden, Mass.

Benson was born in Salem, Massachusetts, where he spent most of his life. He taught art for forty years in Boston, spending summer vacations with his family in Maine, where he painted many scenes of his family relaxing outside on a sunny hilltop. Benson was also a great outdoorsman, and he liked to paint wildlife and hunting scenes.

William Glackens
1870–1938

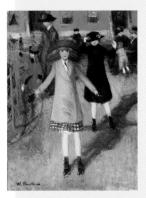

Children Roller Skating,
from the Brooklyn
Museum of Art,
Brooklyn, N.Y.

Glackens was born in Philadelphia, where he began as a newspaper reporter and illustrator. In 1895, he traveled in Europe, painting parks and cafés in Paris. Glackens returned to New York to work as an illustrator. One magazine sent him to Cuba in 1898 to cover the Spanish-American War. When he returned to New York, he painted city scenes, many of Washington Square and Central Park.

John Sloan
1874–1951

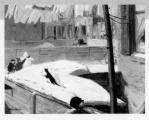

Backyards, Greenwich Village,
from the Whitney Museum of
American Art, New York, N.Y.

Sloan was born in Lock Haven, Pennsylvania. He began his career as an illustrator for newspapers and magazines. In 1896, he began painting, and in 1904, he moved to New York City. There he liked to walk the city's streets and look for subjects to paint, especially in Greenwich Village. *Backyards, Greenwich Village* is Sloan's painting of the yard outside his apartment.

Harvey Dunn
1884–1952

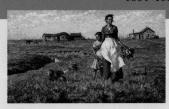

The Prairie is My Garden,
from the South Dakota Art
Museum, Brookings, S.D.

Dunn was born and raised in a sod house in South Dakota. He worked on neighbors' farms to earn money for art school. In 1906, he opened his own studio, illustrating magazines and books, and painting portraits. He was one of eight artists chosen to be a reporter in World War One. During the war, he painted the American troops on the front lines in France. When the war ended, he settled in New Jersey, where he painted scenes of frontier life.

Palmer Hayden
1890–1973

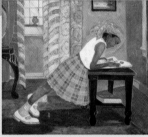

Mother Goose Tales, from a private collection

Born in Virginia, Palmer Hayden was originally named Peyton Hedgeman. But when he was in the army during World War One, his sergeant mispronounced his name as Palmer Hayden. The new name stuck. Hayden belonged to a group of African American artists, writers, and musicians who lived in Harlem, a part of New York City. During the 1920s, these artists created great works of art, and this period of creativity is known as the Harlem Renaissance.

Doris Lee
1905–1983

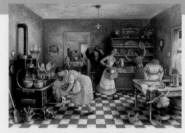

Thanksgiving, from The Art Institute of Chicago, Chicago, Ill.

Lee was born in Illinois, the fourth of six children. She liked to paint scenes of American life, and her Midwestern roots can be seen in her work. *Thanksgiving* earned her national recognition and won a prize at The Art Institute of Chicago in 1935. *Thanksgiving* became very popular, appearing on posters and greeting cards.

William H. Johnson
1901–1970

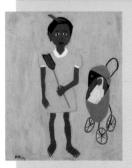

Li'l Sis, from the Smithsonian American Art Museum, Washington, D.C.

Johnson was born in South Carolina. At 17, he moved to New York City, where he studied art at the National Academy of Design. After graduating, he went to study in Paris. Johnson's travels also took him to Norway and North Africa before he returned to New York City in 1938. It was then that Johnson began painting African American subjects. *Li'l Sis* shows Johnson's unique modern style.

Norman Rockwell
1894–1978

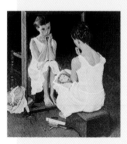

Girl at Mirror, from the Norman Rockwell Museum at Stockbridge, Mass.

Rockwell was born in New York City. He studied art there, as well as in Paris. Rockwell is best known for his realistic images of everyday American life. For over forty years, he illustrated covers for the *Saturday Evening Post,* often asking his neighbors to model for him. He met the girl featured in *Girl at Mirror* at a basketball game. Rockwell's work appears not only in magazines but also in books, calendars, posters, and greeting cards.